BIOGRAPHIC
REMBRANDT

BIOGRAPHIC
REMBRANDT

SOPHIE COLLINS

AMMONITE
PRESS

First published 2017 by
Ammonite Press
an imprint of Guild of Master Craftsman Publications Ltd
Castle Place, 166 High Street, Lewes, East Sussex, BN7 1XU,
United Kingdom

www.ammonitepress.com

ISBN 978 1 78145 302 5

Publisher: Jason Hook
Concept Design: Matt Carr
Design & Illustration: Matt Carr & Robin Shields
Editor: Jamie Pumfrey
Consultant Editor: Dr Grant Pooke

Colour reproduction by GMC Reprographics
Printed and bound in Turkey

Picture Credits:
Shutterstock/EverettArt: 28, 29, 58; National Gallery of Art/www.nga.gov: 31,
83r; The Metropolitan Museum of Art/www.metmuseum.org: 61; Getty Images/
Heritage Images: 70, 83l, 83b; Rijksmuseum/www.rijksmuseum.nl: 79, 82;
Nationalmuseum/www.nationalmuseum.se: 82; J. Walter Thompson Amsterdam: 91.

CONTENTS

ICONOGRAPHIC

WHEN WE CAN RECOGNIZE AN ARTIST BY A SET OF ICONS, WE CAN ALSO RECOGNIZE HOW COMPLETELY THAT ARTIST AND THEIR WORK HAVE ENTERED OUR CULTURE AND OUR CONSCIOUSNESS.

INTRODUCTION

Everyone feels they know Rembrandt. With around 90 self-portraits on record, some of them among the most-reproduced paintings ever made, we not only know how he looked, but we can watch him age like a familiar friend. We can see the confident, aspirational young painter; later, the accomplished, knowledgeable master; and still later, the old man, perhaps disillusioned but also full of the constantly referenced 'humanity' that it was one of his enduring gifts to portray.

But what makes him so instantly recognizable? What was his life really like, and how did it work its way into his art? Bar a very few years immediately after his death when a few gossipy biographers were less than complimentary about his skills and his personality, his enduring popularity has lasted for more than three centuries.

"IN THESE TWO PICTURES THE DEEPEST AND MOST LIFELIKE EMOTION HAS BEEN OBSERVED [AND RENDERED]. AND THAT IS ALSO THE MAIN REASON WHY THEY HAVE BEEN SO LONG IN MY HANDS."

—Rembrandt, in a letter explaining late delivery, to his patron Constantijn Huygens, 12 January 1639

And to offer the contemporary viewer a feeling of such familiarity is rare: while we may admire the portraits and self-portraits of his near-contemporaries such as Van Dyck and Rubens, they don't give us the immediate feeling of comradeship that Rembrandt does. Van Dyck and Rubens don't seem, in the same way, to transcend time and place and put us, whoever and wherever we are, straight into the room with the sitter, whether that sitter was his wife, his lover, his son or a patron paying over and above the going rate to have his portrait painted by one of the most admired artists of his day.

We don't have many words to go with the paintings. Rembrandt speaks to us only through his compositions – just a handful of letters survive, all dealing with the commercial aspects of his work. Nonetheless, we know quite a lot about his life: the early training and fast-coming success; the marriage to an heiress, then the sadness of her death, and the deaths of three out of their four children. He subsequently took first one mistress and then another, the latter to become his partner for the rest of his life. And he suffered troubles in his later life, dogged by personal tragedy and financial difficulties.

Yet none of these problems worked against his art: they seem only to have strengthened his vision when it came to putting life onto canvas, or into etchings. He painted those in his life as they were. Admirers of the high finish of contemporary French and Italian artists mocked his adherence to painting what he actually saw, while some of his many students told unflattering stories about his love of money and his lack of sophistication. But Rembrandt, who painted his way through success, failure, love, death, youth and age, who left his final work unfinished on his easel, still has the last laugh.

> "... A BIBLICAL LEGEND, A CARCASS OF AN OX, A NAKED WOMAN, HIS OWN SELF-PORTRAIT — ALL STAND AS SYMBOLS OF AN ALL-EMBRACING SYMPATHY. PERHAPS ONLY SHAKESPEARE, IN ANOTHER ART, HAS THAT KIND OF UNIVERSAL INTELLIGENCE."

—Sir Herbert Read, art critic, 1957

What more can we learn about Rembrandt? We can look at the context in which his works were produced, and at life in the Dutch Republic in the mid-17th century: at what it was like to be an apprentice; at what you could expect to be paid (and at the aspects of a commission that might make it worth more); at what it might be like to undertake the group commissions, which were popular at the time, and at what props you might find – old clothes and armour, perhaps – that could be used to keep your paintings on biblical and mythological subjects interesting. We can look inside his house and read the inventory of all his possessions, from classical sculptures to, literally, dirty laundry. We can imagine what it would be like to lose almost everyone who matters to you before you die yourself, and how it might feel when your work moves from the height of fashion to being yesterday's news. If we can walk a mile in Rembrandt's shoes, we can return to the pictures refreshed – and with even more appreciation of the depth of his achievement.

> "A WORK IS FINISHED WHEN THE MASTER HAS ACHIEVED HIS INTENTION IN IT."

—Arnold Houbraken, quoting Rembrandt after the latter's death

REMBRANDT VAN RIJN

01
LIFE

"REMBRANDT GOES SO DEEP INTO THE MYSTERIOUS THAT HE SAYS THINGS FOR WHICH THERE ARE NO WORDS IN ANY LANGUAGE ... "

—Vincent van Gogh, letter to Theo van Gogh, October 1885

REMBRANDT HARMENSZOON VAN RIJN

was born on 15 July 1606 in Leiden, in the Republic of the Seven United Netherlands – more usually called the Dutch Republic.

Located between Amsterdam and The Hague, Leiden had played an important part in the Eighty Years' War. It emerged from Spanish rule in the early 17th century into a state of bourgeois prosperity, although it was a long time before it would enjoy peace. Leiden was the second city of the Republic – the first was Amsterdam – and became famous for its textile and printing industries. Its new university, the first in the Netherlands, was founded in 1575.

Rembrandt was the ninth of – probably – 10 children of Harmen Gerritzoon van Rijn, a miller, and his wife, Neeltje Willemsdochter van Suydbroeck, who was the daughter of a baker. Seven of their family are believed to have survived beyond infancy. The couple, themselves solidly and comfortably working class, seem to have brought them up carefully, with attention to their future prospects. After four years at the prestigious Latin School, Rembrandt was entered for the university in Leiden. However, as Jan Orlers, author of the first biographical note on the artist, related: "By nature he was moved toward the art of painting and drawing." Rembrandt was soon enrolled, instead, in an artist's studio, where he began to learn the basics of his chosen career.

NETHERLANDS

LEIDEN

Also born in Leiden: ▶
Jan Steen (1626–79),
popular genre painter and
contemporary of Rembrandt

THE WORLD IN
1606

DECEMBER

Three ships of the London Company set sail from England to establish a colony in Virginia (they arrive in Chesapeake Bay in April of the following year).

JANUARY

The Portuguese navigator and adventurer Pedro Fernandes de Queirós discovers a number of islands – later to become the Pitcairn group – on a Spanish-sponsored trans-Pacific voyage while attempting to discover Australia.

MAY

The painter Caravaggio kills Ranuccio Tomassoni during a quarrel.

At the time of Rembrandt's birth, the Dutch had already been embroiled for almost 40 years in their fight for independence from Spanish rule. The struggle, later to become known as the Eighty Years' War, would continue for another 40. After a number of successes, the Republic of the Seven United Netherlands was established in 1581, and the threat to key Dutch homelands became considerably less immediate. In terms of trade and economic development, the Republic was thriving in 1606 and continued to do so over Rembrandt's lifetime. There is no record of Rembrandt himself ever having travelled, so events in distant lands would affect him only at second hand.

AUGUST

Shakespeare's *Macbeth* premieres at Hampton Court Palace, in front of James I of England.

The Dutch cartographer Jodocus Hondius creates a new map of Japan. It will be the last for over two centuries as Japan is about to close relations with the outside world. It appears as one of 37 new maps for the new Dutch edition of Mercator's *Atlas*.

MAY

Tsar Dmitry II (known as the 'false Dmitry') of Russia is murdered during his wedding celebrations, sparking civil war.

AUGUST

The Dutch fleet is defeated by the Portuguese at the Battle of Cape Rachado.

JANUARY

Guy Fawkes and seven co-conspirators in the Gunpowder Plot are put on trial in Westminster Hall, London.

APRIL

The Dutch fleet mounts a fresh blockade on Goa, on the west coast of India, as part of their ongoing struggle with the Portuguese to control trade around the Indian coasts and in the East Indies.

FEBRUARY

Dutch navigator Willem Janszoon lands on Cape York Peninsula, the first recorded landing on Australia by a European.

FATHER
Harmen Gerritzoon
van Rijn
(1568–1630)

Gerrit van Rijn
(c. 1590–1631)

Adriaen van Rijn
(Died 1652)

Willem van Rijn
(c. 1603–1655)

WIFE
Saskia van Uylenburgh
(1612–42)

Rembrandt
Harmenszoon van Rij(n)
(1606-69)

Rombertus van Rijn
(1635-6)

Cornelia van Rijn
their second daughter
of the same name
(b. & d. 1640)

Cornelia van Rijn
(b. & d. 1638)

Titus van Rijn
the only child who survive(d)
to adulthood, even then he
pre-deceases his father
(1641–68)

Magdalena van Loo
(1641–69)

Titia van Rijn
(1669–1715)

MOTHER
Neeltje Willemsdochter van Suydbroeck
(c. 1568–1640)

Cornelis van Rijn
(Died c. 1639)

Machtelt van Rijn
(Died 1625)

Lijsbeth van Rijn
(c. 1609–55)

There were also three children who did not survive infancy

Hendrickje Stoffels
generally accepted as Rembrandt's common-law wife, mother of his third daughter, also named Cornelia
(1626–63)

MISTRESS
Geertje Dircx
(c. 1605/10–1656)

Cornelia van Rijn
(1654–84)

REMBRANDT'S FAMILY TREE

Rembrandt's parents may not themselves have had much education – although there is some evidence that they were both literate – but they seem to have been conscientious about their children's prospects. Dates and facts are scanty for most of their progeny (they probably had 10 children, of whom seven, it is thought, survived beyond infancy), but all known details point to the fact that their children pursued careers according to their natural gifts. One son went into his father's profession as a miller, while another became a shoemaker. Only Rembrandt had the – evidently natural – facility that directed him towards the arts, in his lifetime regarded as a profession like any other.

RIGHT PLACE, RIGHT TIME

1606

Rembrandt van Rijn is born on 15 July in the prosperous town of Leiden in the Dutch Republic.

1615

Rembrandt attends the Latin School in Leiden.

1620

Rembrandt is listed on the register of the University of Leiden at the age of 14. He seems to have attended only very briefly.

1631

Rembrandt relocates to Amsterdam, using a room in Hendrick van Uylenburgh's house as his studio. His partner Jan Lievens departs to work in England.

1631

Rembrandt paints his first known portrait of an Amsterdammer, Nicolaes Ruts (right).

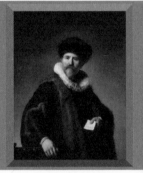

1634

Rembrandt marries Saskia van Uylenburgh. He becomes a citizen of Amsterdam and joins the town's St Luke's Guild, the specialist guild for painters.

1635

Rembrandt and Saskia move into a house on the Nieuwe Doelenstraat. In December, Saskia gives birth to Rombertus, but he survives only eight weeks.

1638

In July, Rembrandt and Saskia's second child, Cornelia, is born, but she lives for only a month.

Rembrandt was born in the right place and at the right time to realize his talents. Not only was he lucky in having parents who were concerned with fostering their children's natural gifts, but the citizens of the Dutch Republic – pious and wealthy – were enjoying unprecedented economic success, to the point at which they could appropriate some of the trappings that had previously only been available to princes and the nobility. They wanted pictures for their walls, and they wanted portraits of themselves, in order to make their success a matter of record. The flexible young painter from Leiden proved to have exactly the skills they needed.

c. 1621

He joins the studio of Jacob Isaakszoon van Swanenburgh in Leiden as an apprentice where he remains for about three years.

1624

Rembrandt joins the studio of Pieter Lastman in Amsterdam for six months. He may also have worked with the artist Jacob Pynas after leaving Lastman's employ.

1625

Rembrandt returns to Leiden and sets up his own studio, which he shares with his friend and fellow artist, Jan Lievens.

1630

In April, Rembrandt's father dies.

c. 1628

Rembrandt produces *Supper at Emmaus*, along with some of his early self-portraits.

c. 1628

Isaac de Jouderville and the young Gerrit Dou, who will become known for his domestic interiors, join Rembrandt's studio as pupils.

1639

The couple move into a house on Sint Antoniesbreestraat. Rembrandt completes the *Passion* series.

1640

Rembrandt and Saskia's second daughter, also named Cornelia, is born, but dies after a few weeks. In September, Rembrandt's mother dies.

1641

In September, Rembrandt and Saskia's son Titus is born. He is the only one of the couple's four children to survive beyond infancy. Rembrandt begins work on *The Night Watch*.

AN APPRENTICE AT WORK

It is believed that Rembrandt went into an apprenticeship with the established painter Van Swanenburgh in Leiden at some point in 1621. He would have been 14 or 15 – on the mature side for an apprentice – and in 1624 moved on to the studio of Pieter Lastman in Amsterdam, before setting up in his own studio. Rembrandt himself would employ a large number of pupils and apprentices. The apprentice's relationship with his master could be a complex one. Typically, though, a good pupil would advance to painting work for his master to sell, as well as learning his trade in the workshop – and would pay for the privilege. A canny artist with several pupils could gain a healthy second income from them.

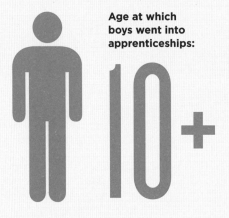

Age at which boys went into apprenticeships:

10+

Length of an apprenticeship:

4 – 6 YEARS

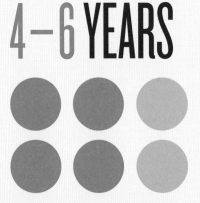

The cost of an apprenticeship was around

20 GUILDERS

per year if the apprentice lived at home; more if he lodged with his master. Acknowledged masters – such as Rembrandt would become – might charge considerably more. Learning to paint was expensive – by contrast, school fees were between two and six guilders per year.

CHORES INCLUDED:

Keeping the studio clean and tidy.

Grinding pigments to make paint.

Stretching and preparing canvases.

Preparing the master's palette with fresh paint in the right colours for work in hand.

SKILLS:

- At first, apprentices would copy from drawings or prints.

- When they had become skilled at copying, they would draw from casts, often of classical sculpture.

- When apprentices were accomplished at drawing from casts, they would draw from a live model.

- When they had acquired all these skills, they would copy from existing paintings, often those of their master. If good enough, these copies would then be sold for extra income.

MEMBERSHIP OF THE GUILD:

6 years of formal training was needed before apprentices became eligible to join the Guild of St Luke.

Members of the Guild typically earned

1,150 – 1,400

guilders per year. By comparison, a trained carpenter earned around 300–400 guilders.

At the height of his success, Rembrandt would earn much more than a typical artist. A single modest portrait commission might earn him as much as

500 GUILDERS

He also pulled in an estimated

2,500 GUILDERS

per year from the fees of his own apprentices.

REMBRANDT'S WOMEN

The more snobbish of Rembrandt's contemporary critics singled out his depictions of women for particular censure. Why, they wondered, were classical or biblical subjects, such as Danae or Bathsheba, depicted in such a realistic way – with dimpled knees and sagging breasts, garter marks and double chins? The modern eye sees something quite different: real women, in real and everyday situations, seen with warmth and realism. And, just as he used himself, Rembrandt used the women around him as models. So, we see quite a lot of the three – Saskia, Geertje and Hendrickje – who were most important in his life. How successful were these three relationships?

SASKIA VAN UYLENBURGH

1612–42

Relationship?
Wife. Cousin of Rembrandt's colleague Hendrik van Uylenburgh, and heiress.

Money?
Yes, Saskia brought both money and goods to the marriage, and Rembrandt continued to receive income from her inheritance after her death.

Children?
Yes, but only one of the four she bore, Titus, survived into adulthood.

Affection?
The painted, etched and drawn evidence shows a warm bond and a mutual enjoyment of the good things in life.

HENDRICKJE STOFFELS

1626–63

Relationship?
Maid, mistress and ultimately common-law wife.
Single when she entered Rembrandt's household, as housekeeper and carer for Titus, somewhere between 1646 and 1649.

Money?
No, Hendrickje joined the household as an employee.

Children?
One daughter, Cornelia.

Affection?
Apparently a close, long-lasting relationship which endured difficulties. It's likely that Rembrandt never married her because he would have lost the income from Saskia's estate. Her status as mistress led to condemnation by her local church council but, after some years, she was treated as the painter's common-law wife, a semi-official status.

GEERTJE DIRCX

c. 1610/1615–c. 1656

Relationship?
Maid and mistress.
Widow when she entered Rembrandt's household, as Titus's nurse, in c. 1642/3.

Money?
No, Geertje came to the household as an employee, hired to look after the infant Titus after Saskia's death. Seems to have been strongly aware of money and made considerable financial calls on Rembrandt when their relationship ended.

Children?
None

Affection?
Ultimately, no. Quarrelled with Rembrandt in 1649 and sued for breach of promise when he refused to marry her.

THE HOUSE AT BREESTRAAT

Rembrandt lived in a handsome brick merchant's house for nearly 20 years, taking out a mortgage on it in 1639. Its ownership marked his arrival as a successful, admired artist and a notable figure in society. In terms of its size, its style and its location, the house reflected his perception of his standing, as well as offering plenty of room for family and servants, together with a fine studio and space to store his huge collection of props and curios. It was also ultimately to spell his financial downfall, as he failed to manage his money well enough to maintain such a substantial household and continue to pay the mortgage.

RESTORATION

The house fell into poor repair in the 19th century. A full restoration was undertaken between 1908 and 1911, after which the building became a museum. It was thoroughly modernized in 1998–9, after which some rooms were furnished, or refurnished, to how they would have been in Rembrandt's day, including the Kunstcaemer, the room that contains Rembrandt's own collection of curios and art.

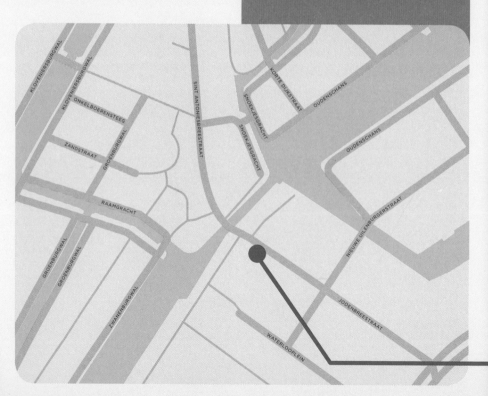

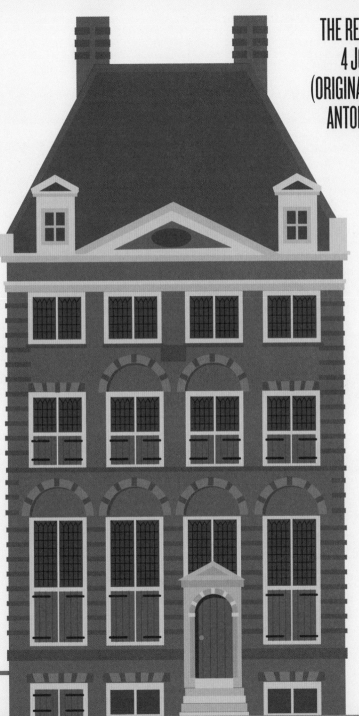

THE REMBRANDT HOUSE,
4 JODENBREESTRAAT
(ORIGINALLY PART OF SINT
ANTONIESBREESTRAAT)
AMSTERDAM

BUILT:
1606

REMBRANDT
LIVED HERE :
1639—58

PRICE IN 1639:
13,000
GUILDERS

LIFE GOES ON

Biographers often divide Rembrandt's life into two dramatically different sections – the good times, which included the professional success of his youth, the wealth he accrued and his happy marriage to Saskia; and the darker period after his young wife's death, when extravagance and ill fortune seemed to attack his happiness, and his professional reputation faded. The true picture is more complex. Not only was Rembrandt clearly able to find inspiration even at times of personal hardship or even tragedy, but some aspects of his professional success were lifelong; his etchings, for example, sold well consistently until his death, and he was still receiving commissions in his last few months.

c. 1646–9

Hendrickje Stoffels joins Rembrandt's household as carer for Titus.

1648

Construction starts on a grand new town hall for Amsterdam.

1649

Rembrandt falls out with Geertje Dircx, who sues him for breach of promise.

He is obliged to pay her an annual allowance of 60 guilders.

1654

In October, Hendrickje Stoffels gives birth to Rembrandt's daughter, Cornelia.

Rembrandt paints *Portrait of Jan Six* (above)

1656

Rembrandt paints *The Anatomy Lesson of Dr Deijman*.

Rembrandt's money troubles come to a head and he is forced to declare bankruptcy.

The detailed inventory taken of his possessions survives today.

Th. J. Haringh, the auctioneer, starts the sale of Rembrandt's possesions.

1658

The concluding sale of Rembrandt's house and possessions is held.

Titus and Hendrickje join forces to create an art dealership.

Rembrandt's house is signed over to his creditors as the final stage in his bankruptcy. The family moves from Sint Antoniesbreestraat to Rozengracht.

1660

Titus and Hendrickje 'employ' Rembrandt in their business to protect him from his creditors.

1662

Rembrandt paints *The Sampling Officials of the Amsterdam Drapers' Guild* (above) and *The Conspiracy of the Batavians under Claudius Civilis* for the new Amsterdam Town Hall. The second painting is taken down just months after being unveiled.

1663

In July, Hendrickje dies. She is buried in a 'temporary' grave (rented, on the understanding that it would be reused) in the Westerkerk.

1665

Rembrandt paints *The Jewish Bride.*

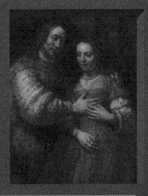

1668

On 28 February, Titus marries Magdalena van Loo. He dies in the same year and is buried in the Westerkerk on 7 September.

1669

Magdalena gives birth to Titus's daughter, named Titia, who is baptised with Rembrandt standing as godfather.

Rembrandt paints his final self-portrait, which is now in London's National Gallery.

On 3 or 4 October, Rembrandt dies.

On 8 October, Rembrandt's funeral is held; he is buried in a rented grave in Amsterdam's Westerkerk.

A LIFE IN INVENTORY

All his adult life, Rembrandt was extravagant. He earned plenty, but he spent more. Soon after he married Saskia, her relations complained that the couple were disposing of her fortune carelessly. Rembrandt's riposte was a cheerful portrait of the two of them, Saskia seated on his knee, drinking a toast to the future.

Eventually his lifestyle caught up with him. In 1656, he was declared bankrupt and a sale of goods ordered. The contents of the house at Jodenbreestaat were made up into 363 lots – listed on 25 and 26 July, and ranging from dozens of important artworks and scores of curios to the final, poignant element: the 'few collars and cuffs' that were recorded as still being out at the laundry.

AUCTION

363 LOTS

including Paintings, Sculptures, Books, Furniture, Clothing and other Curiosities.

25 & 26 JULY 1656

13 PIECES OF ARROWS, BOWS, SHIELDS, ETC

1 HEAD OF CHRIST, A STUDY FROM LIFE

23 SEA AND LAND ANIMALS

2 PORCELAIN CASSOWARIES

A QUANTITY OF ANTLERS

17 HANDS AND FEET, CAST FROM LIFE

1 DEATH MASK OF PRINCE MAURICE, CAST FROM HIS OWN FACE

9 GOURDS AND BOTTLES

1 GIANT'S HEAD

13 PIECES OF BAMBOO WIND INSTRUMENTS

THE SKINS OF A LION AND A LIONESS WITH TWO MULTICOLOURED COATS

REMBRANDT'S DEATH

Rembrandt died on either

3 OR 4
OCTOBER 1669

(accounts vary), 11 months after
the death of Titus, his only son.

He was buried in the Westerkerk in
Amsterdam, local church to his last
home on Rozengracht. Although
the exact location of his grave is not
known, a handsome memorial marker
is placed high on the north wall
of the church.

Rembrandt worked up until the end. His final commission, *Simeon in the Temple*, from
one of the Van Cattenburch brothers (well-known collectors in Amsterdam) was found
unfinished in his workshop when he died. It is now in the Nationalmuseum, Stockholm.

REMBRANDT VAN RIJN

02
WORLD

"WHAT OTHER COUNTRY COULD ONE FIND IN WHICH ALL THE LUXURIES AND ALL THE RARITIES OF LIFE THAT ONE COULD DESIRE ARE SO EASILY AVAILABLE?"

—René Descartes (1596–1650), writing of the wonders of the Netherlands, and of Amsterdam in particular, to his friend, the author Jean-Louis Guez de Balzac

A BRIGHTER SHADE OF YELLOW

Many colours that seem quite ordinary today were still startlingly novel in the 17th century. The stinging, bright yellow of gamboge only became available to European artists in the second decade of the century – it had long been familiar in Indian and Chinese art – so would have been quite new to Rembrandt, who used it for some of the warm, golden effects that offset his masterful chiaroscuro. First imported to the Netherlands, it quickly made its way all over Europe.

01 Gamboge derives from the resin of the *Garcinia* family, most commonly the *Garcinia hanburyi* or *Garcinia morella* trees that grow in warm habitats, ranging from Cambodia (from which the pigment originally got its name) and southern China to Sri Lanka. The resin, which has medicinal as well as artistic uses, was drained through the bark of the tree into hollow bamboo pipes during the rainy season – the best harvesting time – and left to harden.

Leaves of the *Garcinia morella* tree

02 Once hardened, the bamboo stems were split open and the centres – solid cylinders of a powdery, muddy brown – were wrapped in leaves and shipped to Europe.

03 When the so-called 'pipe gamboge' arrived in European trading centres, it was broken into smaller pieces and passed on through merchants.

04 Artists would buy small pieces – gamboge was expensive, as befitted its exotic origins – and grind them into pigment. The unpromising, dry brown resin produced a gloriously vivid yellow when mixed with a binder, such as oil, as Rembrandt used it.

Gamboge resin

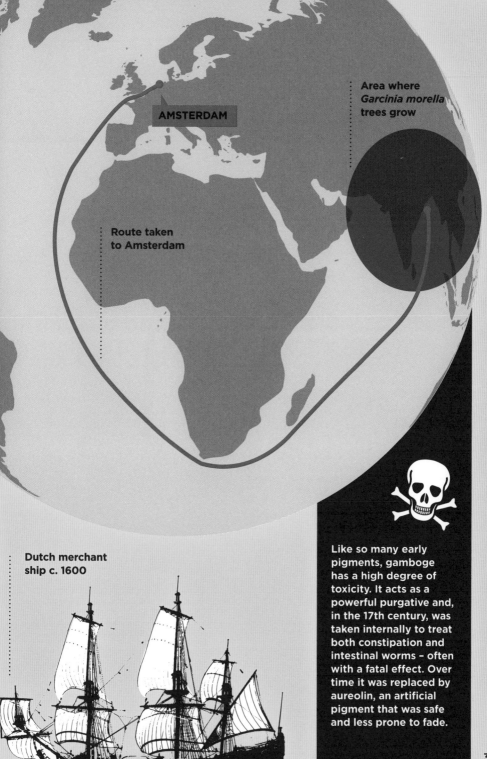

Area where *Garcinia morella* trees grow

AMSTERDAM

Route taken to Amsterdam

Dutch merchant ship c. 1600

Like so many early pigments, gamboge has a high degree of toxicity. It acts as a powerful purgative and, in the 17th century, was taken internally to treat both constipation and intestinal worms – often with a fatal effect. Over time it was replaced by aureolin, an artificial pigment that was safe and less prone to fade.

TULIP FEVER

Rembrandt shared with many of his contemporaries the magpie acquisitiveness that underpinned the 'tulipomania' which took possession of the Low Countries in the 1630s. This was surely one of the oddest speculation bubbles ever.

As tulip bulbs themselves became ever pricier, those who could no longer afford them commissioned tulip-themed tiles or paintings to decorate their homes. In the mid-1600s, a virtuoso still life of flowers might cost 1,000 guilders; a less ambitious one, around 500. Despite the fact that a whole category of tulips is today named after him, Rembrandt didn't follow the trend for painting flowers.

IN 1647
ONE
VICEROY TULIP BULB SOLD FOR
2,500
SILVER FLORINS

FOR THE SAME PRICE, THE BUYER COULD HAVE BOUGHT ALL THIS:

2 X CARTLOADS OF WHEAT

4 X CARTLOADS OF RYE

4 X OXEN

8 X PIGS

12 X SHEEP

2 X BARRELS OF BUTTER

2 X HOGSHEADS OF WINE

1,000 POUNDS OF CHEESE

1 X SUIT OF FINE CLOTHES

4 X BARRELS OF BEER

1 X 4-POSTER BED WITH HANGINGS AND LINEN

AND ...

1 X SILVER BEAKER

PLAGUE

The 17th century was a rich one in Europe for the development of the arts and culture, but it had a darker distinguishing feature: it was a bad century for plague. 1656 was not just the year in which Rembrandt was declared bankrupt, it was also the year that a major outbreak of plague came to Amsterdam, and the latter is likely to have been quite as worrying to the artist as the former. The preceding year had seen an outbreak in Leiden, his birth city, and other major European cities were dogged by plague in the second half of the century.

The vast number of trade ships visiting the ports of the Dutch Republic carried rats that bore fleas which spread the plague. The belief at the time was that plague was caused by 'bad air'. Plague would pop up again and again in 17th-century Holland, reaching a crescendo in the outbreak of 1664 in Amsterdam that claimed 24,000 lives.

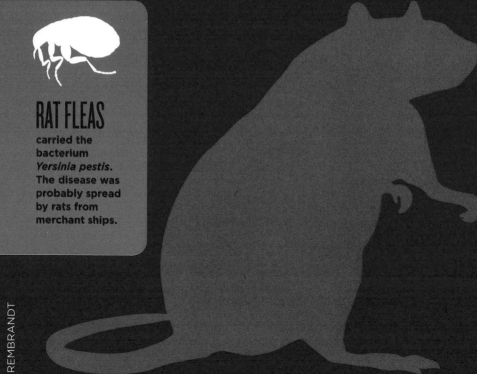

RAT FLEAS

carried the bacterium *Yersinia pestis*. The disease was probably spread by rats from merchant ships.

LEIDEN

1655

25% OF THE POPULATION KILLED

AMSTERDAM

1656

1663

1664

THE THREE OUTBREAKS TOTALLED AROUND 52,000 DEATHS – ROUGHLY 25% OF AMSTERDAM'S POPULATION

REMBRANDT'S AMSTERDAM

1 The studio of Pieter Lastman, Rembrandt's teacher in 1624.

2 Bloemgracht: Rembrandt's first Amsterdam studio, set up in 1635.

3 Sint Antoniesbreestraat no. 4: Rembrandt's house, bought for 13,000 guilders in 1639, but never paid for. Sold at auction in 1658.

4 Singel: where Titus van Rijn lived after his marriage to Magdalena van Loo in 1668, before his death later the same year.

5 Rozengracht: site of the house in which Rembrandt spent his last decade.

6 Westerkerk: where Rembrandt and Titus were buried.

7 Oude Kerk: where Rembrandt purchased a temporary tomb for Saskia when she died in 1642.

8 Keizersgracht: site of the home of the surgeon Professor Tulp, painted in *The Anatomy Lesson of Dr Nicolaes Tulp*.

9 Keizerskroon Tavern: where Rembrandt's possessions were auctioned.

10 Singelgracht: the home of Frans Banninck Cocq, who commissioned *The Night Watch*.

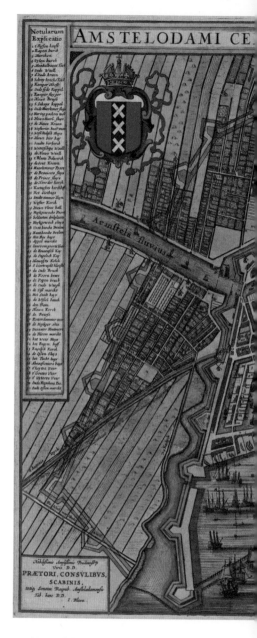

▲ *Map of Amsterdam*
Joan Blaeu, taken from *Atlas Maior*, c. 1662–72

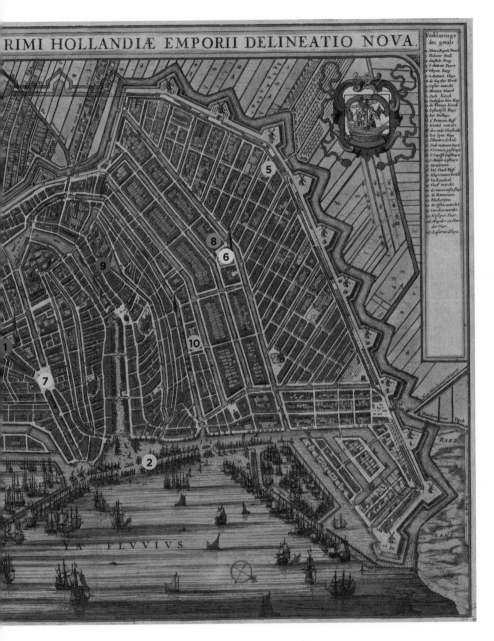

RIMI HOLLANDIÆ EMPORII DELINEATIO NOVA.

Verklaringe
des getals

In the mid-1660s, Amsterdam had a population of around 200,000, and had recently acquired a semicircular surround of canals, constructed to keep it safe from flooding and to improve its accessibility. Within the walls, trade was flourishing and a very diverse population, practising a number of faiths, lived tolerantly together.

JOINING THE CLUB

In the Protestant north, artists could no longer look to the Church for patronage. Luckily, with a lively secular society and plenty of money about, there were other options. Successful merchants and businessmen wished to be painted in the context of their professional lives as members of guilds, or enjoying the activities of clubs – for example, the militia companies. Seldom has the group portrait been more popular.

The militias in Rembrandt's Amsterdam occupied an odd space in society. Originally they had been for soldiers, but by the mid-17th century they had lost most of their military functions – the art historian Robert Hughes defined them as, "Semi-military social clubs for the prosperous."

UNIFORMS:

Open to free interpretation. The rich and dressy young men who were typical of militia members would 'dress high', with plenty of swagger, creating 'uniforms' that often amounted to fancy dress.

CLUBHOUSE:

Each militia had its own *doelen* (clubhouse), where its weapons were stored.

SPECIALIZATIONS:

3 MAIN TYPES

ARCHERS

CROSSBOWMEN

MUSKETEERS (KLOVENIERS)

NUMBER OF MILITIAS IN AMSTERDAM 20+

AVERAGE NUMBER OF MEMBERS 200

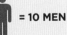 = 10 MEN

ACTIVITIES:

All militias held regular shooting practice and most had a shooting range on their premises. The activity was largely for show.

AN APPETITE FOR ART

Visitors to the Netherlands during the later 17th century were invariably astounded not only by the Dutch enthusiasm for art, but also by the sheer number of pictures that could be seen hung in domestic interiors. While the quality was very variable, often the pictures decorating the walls of a quite modest household – even one that lived in a relatively small house – could be counted in the dozens, whether they were cheaper prints or etchings, or more costly paintings. Of course, there were many levels of quality, even in original paintings – one might buy a piece worked on by an apprentice for far less than one by his master, and small interiors called for small works.

1,000 GUILDERS
THE COST OF AN ACCOMPLISHED PAINTING BY A RECOGNIZED MASTER, SUCH AS GERRIT DOU, WAS THE SAME AS A MODEST BUT COMFORTABLE HOUSE IN AMSTERDAM

5–10 GUILDERS
THE COST OF AN UNDISTINGUISHED PAINTING, PERHAPS BY AN APPRENTICE

In the 1660s, the Guild of St Luke listed nearly **700 ARTISTS** in its mixed membership. That's one painter per 2,500 people in the general population of Holland.

WHERE TO BUY ART?

FOR SALE

You could buy from the painter directly or from a dealer (and many painters dealt in the work of other artists, as well as their own). At the cheapest end, more affordable works might be propped up out on the street for sale, much as in tourist art markets today.

The Dutch market was the first in which a large number of buyers of different tastes and incomes were able to choose what they wanted. Some artists were so much in demand that whatever they produced would sell; artists whose work was slightly less sought-after could make a living by producing paintings to order from a huge range of scenes and motifs.

30 – 50 Number of paintings claimed, by English diarist John Evelyn, to be owned by the average Dutch household.

A CLEAN SWEEP

Over and above their passion for art, one thing every foreigner in the 17th century noticed about the Dutch was their dedication to cleanliness, in a time when neither personal nor public hygiene was taken for granted. One diarist remarked wonderingly that the streets were so spotless that they were enjoyable to walk in, in stark contrast to those elsewhere in Europe. Both the interiors and street views of many of Rembrandt's contemporaries support this: women are seen working in gleaming kitchens, or sweeping from a yard onto an immaculate cobbled street.

One contemporary account goes into more – amazed – detail about the average Dutch household's dedication to chores:

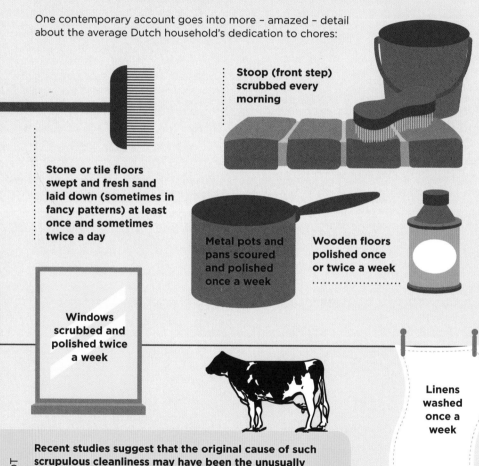

Stoop (front step) scrubbed every morning

Stone or tile floors swept and fresh sand laid down (sometimes in fancy patterns) at least once and sometimes twice a day

Metal pots and pans scoured and polished once a week

Wooden floors polished once or twice a week

Windows scrubbed and polished twice a week

Linens washed once a week

Recent studies suggest that the original cause of such scrupulous cleanliness may have been the unusually high number of households making their own cheese and butter. More than half of Amsterdam's homes made their own in the early 17th century, and dairy products spoilt very quickly indeed if made and kept in less-than-spotless conditions.

03
WORK

"HE ONCE PAINTED A PORTRAIT IN WHICH THE COLOURS WERE SO HEAVILY LOADED THAT YOU COULD LIFT IT FROM THE FLOOR BY THE NOSE."

—Arnold Houbraken, painter and writer, on Rembrandt

REMBRANDT BY NUMBERS

How prodigious was Rembrandt's output? His record-keeping was decried by contemporaries as sloppy, and the number of 'Rembrandts', even now, keeps changing as paintings move in and out of validation. The confusions between his work and that of others arise partly because of the large number of pupils. Rembrandt took on around 50 students in the course of his 40-year career, about 35 of whom became acknowledged painters. It was also the well-established custom at the time to have students copy and finish some of their master's works. A painter as successful as Rembrandt at the height of his fame would hardly have been able to keep up with commissions. Like other artists, he met the need by using pupils as helpmeets to cope with the demand for work.

ESTIMATED NUMBER OF ETCHINGS

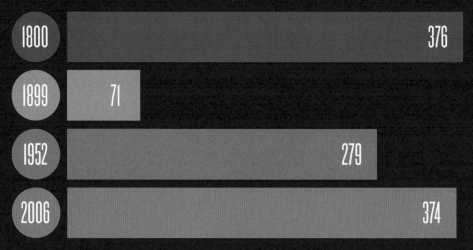

Year	Number
1800	376
1899	71
1952	279
2006	374

In 1800, it was estimated that Rembrandt had made 376 etchings, but by 1899 the number had hugely reduced. In 1952, Ludwig Menz, a German art historian, re-counted and upped the number. In 2006, the Rembrandt scholar Gary D. Schwartz listed 374 – almost back to the total estimated in 1800.

REMBRANDT RESEARCH PROJECT

The Rembrandt Research Project (RRP) is recognized as the final word on what is a Rembrandt composition. Today, even the RRP has acknowledged some changes of mind regarding specific works.

ESTIMATED NUMBER OF PAINTINGS

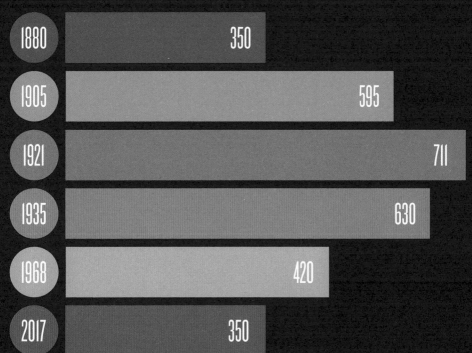

Year	Number
1880	350
1905	595
1921	711
1935	630
1968	420
2017	350

In 1880, a count was made of 350 known paintings by Rembrandt, but in 1905 an eight-volume scholarly catalogue bumped the total up. This was increased again in 1921 by Wilhelm Valentiner, a German art historian and Rembrandt specialist. In 1935 Abraham Bredius, a Dutch art historian and curator, reduced the total, and by 1968 Horst Gerson, a colleague of Bredius, had taken it down further. Today, the acknowledged total is back to approximately 350 paintings, as it was in the late 19th century.

ESTIMATED NUMBER OF DRAWINGS

2,000

The estimated number of drawings produced by Rembrandt has never fluctuated as much as that of the etchings or paintings.

BIOGRAPHIC
THE ANATOMY LESSON OF DR NICOLAES TULP

The Anatomy Lesson of Dr Nicolaes Tulp was an early tour de force in group portraiture from the 25-year-old Rembrandt. It was commissioned by the Amsterdam Guild of Surgeons and each of the subjects depicted would have paid a share of the artist's fee. Rembrandt pulls the onlooker's attention towards Tulp, who is demonstrating the tendons of the forearm to a group of spectators, arranged in a left-leaning pyramid, whose names are listed on the scroll held by the figure to Tulp's right.

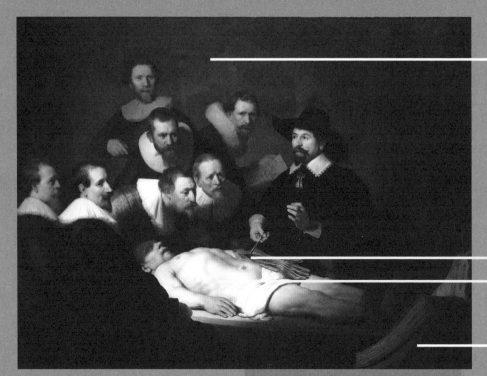

▲ *The Anatomy Lesson of Dr Nicolaes Tulp*
Rembrandt van Rijn
Oil on canvas, 1632
85 x 67 inches (217 x 170 cm)

Original location:
Commissioned for the anatomical theatre of the Amsterdam surgeons in Nieuwmarkt, where it hung until 1828, when it was purchased for the Mauritshuis.

Current location:
Mauritshuis museum, The Hague

17 JANUARY 1632

Anatomies were seasonal work, scheduled for the winter months. They might take several days. Without refrigeration, even with a fresh corpse, summer temperatures meant that the body turned into a stinking mess long before the surgeon had finished his study.

WHOSE BODY?

In the 17th century, bodies used for dissection were, almost without exception, those of executed criminals.

Dr Tulp's subject was Adriaan Adriaanszoon, aka Arents Kintje ('Arents the Kid'), who had been hanged – earlier on the day of the dissection – for robbery with violence.

SURGEON'S VIEW

Contemporary medical students notice with relish that Rembrandt, despite considerable anatomical preparation, has made a mistake, confusing his lateral epicondyle with his medial epicondyle.

The huge tome is an anatomy textbook, most likely Adriaan van den Spiegel's *De fabrica*, published in 1627. It shows the same anatomical mistake as Rembrandt made, so he probably used it himself for research.

WHO CUT IT UP?

The more menial work of dissection was performed by a preparator, who cut the body up ready for the lesson. Tulp, Amsterdam's City Anatomist, would not have got his hands dirty. The knives and tools were then removed, and the lesson begun on a clean 'canvas'.

EARTH PIGMENTS

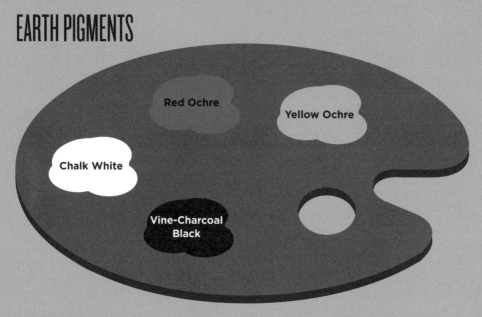

The four earth pigments that formed the foundation of the classical artist's palette.

TITIAN'S PALETTE

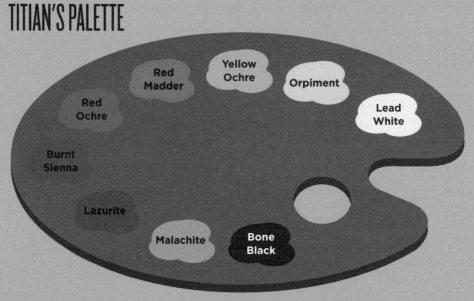

The Venetian painter, Titian's palette was originally said to have employed only nine basic colours, although he used many, many variants as enriching glazes and to create his unique layer effects.

50 SHADES OF BROWN

No one given the opportunity to see a range of Rembrandt's works up close could find anything dull about brown. His rich, earthy shades recall Titian's use of colour (Rembrandt's under-painting, like that of the Italian master, was done almost entirely in shades of brown and deep ochre). His training with Pieter Lastman, who had famously studied in Italy, probably influenced his early colour choices. Although a number of commentators – some of them Rembrandt's ex-pupils – left accounts of his painting practice after his death, none of them said much about the materials he used to create his very specific effects.

REMBRANDT'S PALETTE

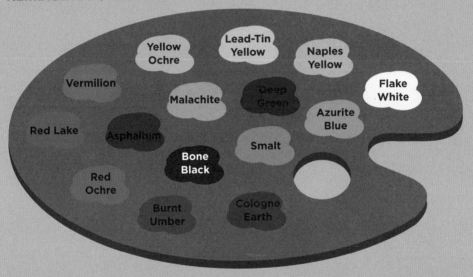

Rembrandt habitually used 15 or more colours, and also mixed colours to rich effect.

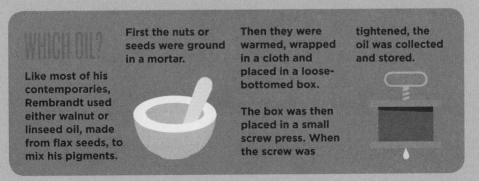

WHICH OIL?

Like most of his contemporaries, Rembrandt used either walnut or linseed oil, made from flax seeds, to mix his pigments.

First the nuts or seeds were ground in a mortar.

Then they were warmed, wrapped in a cloth and placed in a loose-bottomed box.

The box was then placed in a small screw press. When the screw was tightened, the oil was collected and stored.

BIOGRAPHIC
THE NIGHT WATCH

The Night Watch (originally *The Company of Captain Frans Banninck Cocq and Lieutenant Willem van Ruytenburch*) was commissioned by Frans Banninck Cocq, a rich and esteemed figure in Amsterdam society, who had served successfully in wartime. He lived in a mansion on Singelgracht and enjoyed 'marching out' his militia in his spare time. The painting was commissioned in 1640, at what turned out to be the bargain price of 1,600 guilders, with the cost divided between the sitters. When the picture was delivered in the spring of 1642, it was a great success. Viewers admired its original composition – other groups had usually been depicted in long, static friezes – and the lifelike quality of the figures. Banninck Cocq liked it so much that he ordered two copies to be made, and the painting gained its creator much acclaim.

▼ **The Night Watch**
Rembrandt van Rijn, Oil on canvas, 1642
143 x 172 inches (363 x 438 cm)

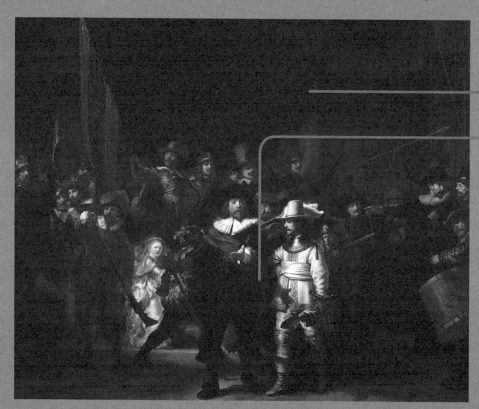

Original location:
Commissioned for the Kloveniersdoelen (the Musketeers' club house), where it hung until 1715, when it was moved, first to the Town Hall, then, in 1808, to the Rijksmuseum.

Current location:
Rijksmuseum, Amsterdam

WHY THE NIGHT WATCH?

Layers of yellowing varnish – plus the smoke from the open fires in the Kloveniersdoelen – gradually darkened the picture until it was forgotten that it had not been created as a night scene. Only when it was cleaned in the 20th century was the illusion dispelled – but by that time, the name had stuck.

The names of the members of the group appear on a shield on the arch above them. These were added by another hand after the painting's completion.

Despite being under almost constant guard, *The Night Watch* has been attacked three times, twice slashed with a knife, in 1911 and 1975, and once with sulphuric acid in 1990. Damage caused by all three attacks was slight, and has been repaired.

34 PEOPLE IN THE PAINTING
including 18 Kloveniers and only one woman

MASTER ENGRAVER

In his own lifetime, Rembrandt's skill at etching was famous and his prints sold quickly to a host of collectors. Etching was the only kind of printing that he attempted, and from his first attempts, in around 1626, he proved unusually adept at manipulating a fairly simple technique. In fact, his results were so impressive and so far ahead of any other artist's work that rumours abounded in Amsterdam that he had developed a secret process. This was not the case: where he did perhaps differ from other etchers was in his willingness to develop work as he printed it. As a result, several different impressions may exist from a single original plate, which he had amended as he worked.

HOW AN ETCHING IS MADE

01 A very thin plate of copper is 'painted' with a paste, the etching ground, which is usually made from a mixture of resin, wax and asphalt.

04 The etching ground is removed from the plate. (Rembrandt used an especially soft mix for his etching ground, enabling him to 'draw' in a loose, sketchy way.)

03 The copper plate is then dipped into an acid bath – usually dilute hydrochloric acid – that eats into the exposed copper. The etching ground is acid-resistant, so those areas of the plate still covered are protected.

02 The artist then draws on his picture freehand, using the fine point of an etching tool, removing the etching ground and exposing the copper to create the lines.

05 The plate is inked, using either an ink roller or a pad, and wiped to remove the excess, so the ink remains in the etched grooves only.

06 The plate has a sheet of dampened paper laid over it.

07 The etching 'sandwich' is then passed through the printing press, and the ink transfers from the grooves to the paper, creating the print.

▼ *Self-Portrait Leaning on a Stone Sill*
Rembrandt van Rijn
Etching on paper, 1639
Plate: 8 x 6 inches (20 x 16 cm)

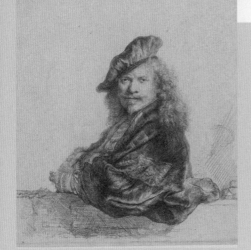

REMBRANDT'S EYES

In 2004, two neuroscientists at Harvard Medical School noticed that many of Rembrandt's self-portraits appeared to show that the artist's eyes were misaligned. After an in-depth measuring exercise using 36 of the self-portraits from different stages in his career – which proved that their initial observation was not a coincidence – they concluded that Rembrandt is likely to have suffered from 'stereo blindness': that is, that he saw things flat rather than seeing them three-dimensionally, with depth.

HOW DOES THIS HAPPEN?

Stereo vision depends on both eyes having an even overlap of vision area. If they see unevenly, or one is aimed in a slightly different direction, the eyes continue to see independently, rather than creating a blended, three-dimensional effect in the brain.

PROBLEM?

Probably not. Art students have always been encouraged to close one eye while focusing on their subject when learning to draw. This helps to render something three-dimensional in just two dimensions. It's even possible that Rembrandt's peculiarity of vision may have been an advantage to him.

SEEING THINGS

Claude Monet suffered from cataracts and created increasingly muted and misty-visioned paintings until he had an operation to correct them.

Georgia O'Keeffe's macular degeneration in older age led her later paintings to become 'flatter' in effect.

HOW YOUR EYES WORK

Stereopsis, as shown below, is how the eyes work to perceive depth and create a three-dimensional image. For Rembrandt, if scholars are correct, this process would not have been possible and instead the objects in front of him would have appeared flat.

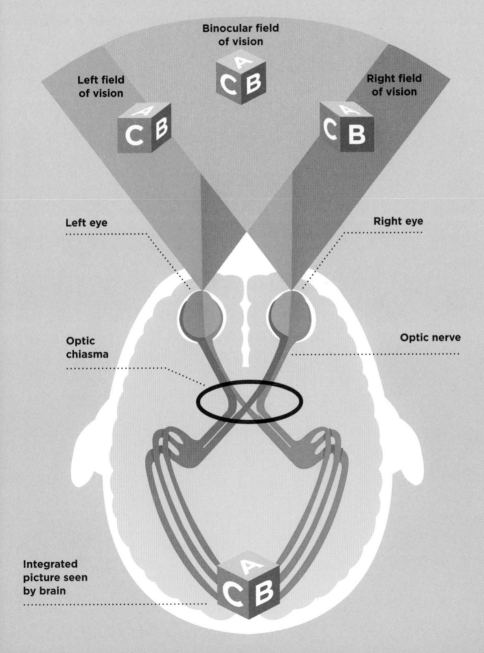

Binocular field
of vision

Left field
of vision

Right field
of vision

Left eye

Right eye

Optic
chiasma

Optic nerve

Integrated
picture seen
by brain

BIOGRAPHIC
BATHSHEBA
AT HER BATH

Hendrickje Stoffels modelled for this, one of Rembrandt's greatest paintings on a biblical subject. In the Bible story, Bathsheba attracts the attention of King David, who sends her husband to certain death so that he can marry her himself. Rembrandt depicts Bathsheba holding a letter from the king, summoning her to his bed. The painting has been praised as being one in which the onlooker can actually see the subject thinking.

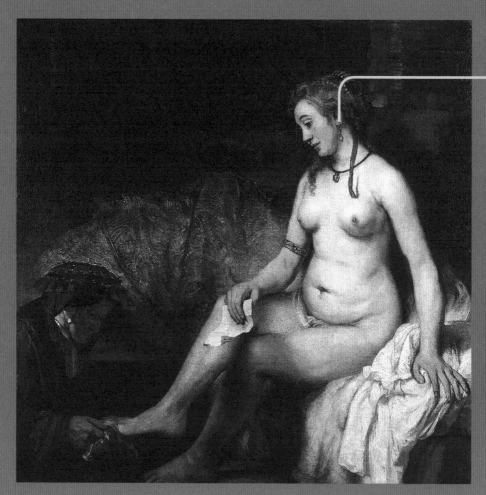

▲ *Bathsheba at Her Bath*
Rembrandt van Rijn
Oil on canvas, 1654
56 x 56 inches (142 x 142 cm)

SASKIA'S EARRINGS

Sharp-eyed viewers noted that the pearl earrings worn by Hendrickje as she models are a pair that originally belonged to Saskia, Rembrandt's wealthy wife. They can be seen in some of her portraits.

EVERYDAY LIFE AND THE BIBLE

Rembrandt has pulled off his usual double in Bathsheba: creating a believable woman, with a luxurious yet everyday body, in the role of a biblical character. Compared with the same subject painted by, say, Rubens, who turns Bathsheba into a glamorous court beauty, Rembrandt has kept her humble. She may be the subject of a king's lust, but she's still, literally, the woman next door.

A DEFIANT MESSAGE

In 1653, the year before *Bathsheba at Her Bath* was completed, Rembrandt and Hendrickje were summoned by the church council for the offence of living in adultery. Rembrandt did not turn up. Hendrickje did, and was castigated and banned from attending services. Depicting Hendrickje as a compromised woman wearing Saskia's jewellery may have been Rembrandt's way of thumbing his nose at the church authorities.

The warm, rich palette of the painting has clear links to the Venetian masters of the previous century. Rembrandt may never have travelled, but he was certainly familiar with the works of Titian and Tintoretto.

REMBRANDT VAN RIJN 1606 – 1669

SELF-PORTRAITS
10%

PORTRAITS
60%

LANDSCAPES
AND SCENES OF DAILY LIFE
5%

BIBLICAL SUBJECTS
20%

MYTHOLOGY AND HISTORY
5%

Rubens was born almost 30 years before Rembrandt, and records from friends and early biographers indicate that Rembrandt much admired him. Their working lives were quite different. Rubens, originally a Protestant refugee, converted to Catholicism and lived in the south of Holland, where both the Catholic Church and the royal courts were major patrons. Altar paintings were a significant part of his output and he painted the Spanish royal family and many other aristocrats. As an artist of the Republic, Rembrandt's clientele were quite different – the bourgeoisie made up the majority of his commissions. There are no altar paintings among his output, and only one royal portrait.

SELF-
PORTRAITS
LESS THAN **1%**

LANDSCAPES
AND SCENES OF DAILY LIFE
9%

ALTAR PAINTINGS
15%
BIBLICAL
SUBJECTS
20%

PORTRAITS
15%

MYTHOLOGY
AND HISTORY
40%

THE LOST DECADE

What happened to Rembrandt after 1642? He had completed and delivered *The Night Watch*, and Saskia died later in the same year. And then, for 10 years, there is an odd artistic silence. His painted output dropped drastically, and for a full decade he produced far fewer works, and no portraits. What he did paint was not his best work and seems curiously 'bitty' for an artist of his stature. Art historians and critics have argued to and fro about why, at the height of his powers, Rembrandt seems suddenly to have lost his mojo – and why, after 1652, he re-emerged with the marvellous works of his so-called 'late style'.

DISCREDITED BY HIS PATRONS?

For many years, a critical belief held that Rembrandt's career had stalled because he had fallen out with Frans Banninck Cocq, who commissioned the *The Night Watch*.

Likelihood?
Unlikely.
The painting was hung in the spot for which it was commissioned and remained there – surely unlikely if it had been the subject of rejection. There is no evidence to show that Rembrandt argued with his patron.

FELL OUT OF FASHION?

This is a theory that first arose in the 1670s, after Rembrandt's death, and grew. Classicism, a fashion originating in France, was becoming an increasingly strong force in painting across Europe, and Rembrandt, definitely a baroque man, no longer fitted the frame.

Likelihood?
Unlikely.
The dates don't fit; the theory is retrospective. By the time the argument emerges, Rembrandt is already dead, having created the sublime work of the 1650s and 1660s.

UNLIKELY

LIKELIHOOD OF LOS

DISTRACTED BY OTHER TECHNIQUES?

Rembrandt may not have painted much for some years, but he etched – and some of his greatest prints were produced during the 1640s. Did he become absorbed by his printmaking and change his preferred medium for a time?

Likelihood?
Possible.
Among the prints produced during this period were the *Hundred Guilder Print*; his largest and most impressive landscape, *Landscape with Three Trees*; and the accomplished *Self-Portrait at a Window*, all masterpieces of etching.

FELLED BY GRIEF?

Rembrandt had had a difficult time personally. Three of his and Saskia's children had died shortly after birth and she herself had succumbed at the age of only 29. It may have been that he found that his grief was simply too strong for him to carry on as normal.

Likelihood?
Unproven.
We don't have any hard information about Rembrandt's feelings on his relationships; death in infancy was common at the period, although of course this does not mean that children went unmourned.

A CRISIS OF CONFIDENCE?

Rembrandt had always been innovative in his colour choices, composition and use of light and chiaroscuro effects. Did he temporarily reach the limit of his development, and feel constrained to enter an experimental period before returning to painting with his virtuoso late style?

Likelihood?
Highly possible.
The paintings that Rembrandt did produce during his fallow years were highly variable in size, composition and subject matter. Unlike his previous works, they don't have evident links to one another. Perhaps the period should be taken as evidence of experimentation.

POSSIBLE

LIKELY

ECADE SPECULATIONS

BIOGRAPHIC
SELF-PORTRAIT
WITH TWO CIRCLES

Rembrandt painted around 50 self-portraits, and this is one of his latest and widely accepted as one of his best. It offers both the realism and the humanity that are so typical of his work. His direct gaze, one eye characteristically shadowed, is aimed straight at the onlooker. Although the painting is undated, he is probably almost 60 years old. The picture is uncluttered by the props or elaborate costumes that have featured in so many of his other paintings.

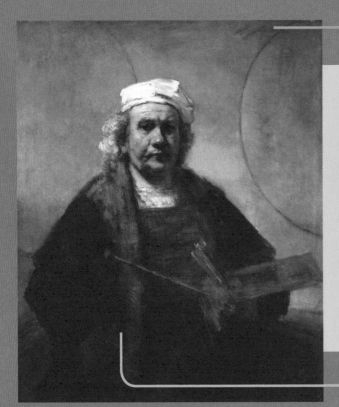

Original location:
Located in the Paris collection of the Comte de Vence in 1750, sold to the Hennessy collection in 1761 for 481 francs. Imported to England and sold first to the Marquess of Lansdowne and then, in 1888, to the Earl of Iveagh. Passed to Kenwood as part of the Iveagh Bequest.

Current location:
Kenwood House, London

▲ *Self-Portrait with Two Circles*
Rembrandt van Rijn
Oil on canvas, c. 1665
45 x 37 inches (114 x 94 cm)

THE CIRCLES

Behind Rembrandt are two carefully drawn partial circles, apparently painted on a fabric hanging. Their oddity has caught the attention of Rembrandt admirers, and attracted a variety of interpretations. What do they signify?

CLASSICAL REFERENCE?

Rembrandt's classical knowledge was good, and the circles may be a playful reference to a story from Pliny. In the story, artist Apelles visits his fellow artist Protogenes on Rhodes, Greece. When Protogenes is out, Apelles leaves a perfect circle on his studio wall, knowing that only he would be able to achieve such freehand perfection – and that Protogenes would know he had been there.

The circle was also Aristotle's measure of perfection – the *rota aristotelis* – a simpler, though still feasible, classical reference.

CONTEMPORARY REFERENCE

Equally, there has been speculation that the circles represent a map of the world – the double hemisphere that is often seen hung in Dutch interiors in contemporary paintings. If the painting was unfinished, perhaps the circles were intended to be filled.

DRESSED FOR WORK

In older age, Rembrandt has stripped back his costume – a simple white cap and a painter's smock underneath a fur-lined gown ensure that the eye is drawn to his face, not to his clothes.

FINISHED?

The painting is not signed. Is it finished? The brushwork is sweeping and 'rough' but this is characteristic of the artist's late style: in some places, he has made marks directly into the thick colour while it is still wet.

BECOMING REMBRANDT

Rembrandt did not begin as Rembrandt. Critics have speculated that, as both his reputation and his confidence grew, so he credited his work with his full name. It may be, too, that as the value of his works rose, it became necessary to make his signature more distinctive and recognizable, the better to verify them.

1625–9

His work is signed with a single 'R' or conjoined initials 'RH' (Rembrandt Harmenszoon) or 'RL' (Rembrandt Leydensis – Rembrandt of Leiden).

1630–1

The initials develop into a more complex monogram, an 'R' and an 'L', the bar between them signifying the 'H' – so Rembrandt Harmenszoon Leydensis.

1632

His surname or patronymic is added to the monogram – 'RHL van Rijn', with a small line between them.

1632–3

The monogram is replaced by 'Rembrant • ft ' meaning Rembrandt did this.

1633–69

The full name becomes 'Rembrandt', with a 'd' between the 'n' and 't' – his mature signature, which he used until the end of his life.

REMBRANDT
VAN RIJN

04
LEGACY

"HE CAN BLEND, LIKE NO ONE ELSE, REALITY WITH MYSTERY, THE BESTIAL WITH THE DIVINE ... THE LONELIEST DEPTHS OF FEELING THAT PAINTING HAS EVER EXPRESSED."

—Paul Valéry, poet and essayist, 1935

THE CRITICS' CHOICE

IN HIS YOUTH ...

Karl Marx remarked – with insight – that, "Rembrandt painted the mother of god as a Dutch peasant woman." Whether or not this was a good thing divided his early critics. He attracted praise very early in his career, and his artistic reputation has only ever really slipped for a period shortly after his death, when the newly fashionable classicists derided his figures as too coarse and mundane. Just a few decades later, the level of his artistic achievement was fully recognized and he has never fallen out of favour since.

"REMBRANDT ... LOVES TO DEVOTE HIMSELF TO A SMALL PAINTING AND PRESENT AN EFFECT OF CONCENTRATION WHICH ONE WOULD SEEK IN VAIN IN THE LARGEST PIECES OF OTHER ARTISTS."

—Constantijn Huygens, writing of the 22-year-old Rembrandt, 1628

AFTER REMBRANDT'S DEATH ...

"ONLY AN UNEDUCATED PERSON TRIES TO CLOTHE HIS FIGURE WITH A CLUMSY DARK GARMENT, AND THESE ARTISTS COMPOSE THE SURROUNDINGS IN SUCH A WAY THAT WE CANNOT MAKE HEAD OR TAIL OF THEM ..."

—Abraham Brueghel, artist and early critic, 1670

"[REMBRANDT] WAS BROUGHT UP IN CONSTANT SIGHT OF SLUGGISH NATURE, AND ONLY KNEW TOO LATE OF A MORE PERFECT TRUTH THAN THAT WHICH HE HAD ALWAYS PRACTISED."

—Roger de Piles, early French biographer, 1699

"HE IS THE PAINTER OF LIFE AND THE HUMAN SOUL."

—Carel Vosmaer, critic and poet, 1868

"ONE DAY PEOPLE WILL PERHAPS DISCOVER THAT REMBRANDT WAS AS GREAT A PAINTER AS RAPHAEL."

—Eugène Delacroix, artist, 1851

"IN A WAY, VERMEER AND REMBRANDT ARE OPPOSITES. BUT REMBRANDT IS THE GREATER ARTIST, I THINK, BECAUSE HE'S GOT MORE INGREDIENTS THAN VERMEER. REMBRANDT PUT MORE IN THE FACE THAN ANYONE ELSE HAS, BEFORE OR SINCE, BECAUSE HE SAW MORE."

—David Hockney, artist, 2016

"THE PSYCHOLOGICAL TRUTH OF REMBRANDT'S PAINTINGS GOES BEYOND THAT OF ANY ARTIST WHO HAS EVER LIVED. OF COURSE THEY ARE MASTERPIECES OF SHEER PICTURE-MAKING."

—Kenneth Clark, art historian and art critic, *Civilisation*, 1969

RECORD BREAKER: REMBRANDT FOR SALE

Any art auctioneer would tell you that art can never be a completely safe investment. Fashion in art comes and goes and ideas about 'worth' change. Still, if you were thinking about investing in Old Masters, Rembrandt would be the closest thing to a safe bet. The drawback? Rembrandt paintings do not come on the market very often, particularly those from his later period when he made fewer works. And when they do, they are expensive. Very expensive.

14 The estimated number of Rembrandt paintings in the world still in private collections.

2000
Portrait of a Lady, Aged 62
Rembrandt van Rijn
Oil on canvas, 1632
29 x 22 inches (74 x 55 cm)

£19.8m/$29m

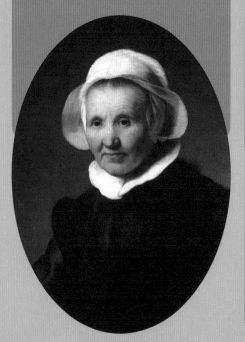

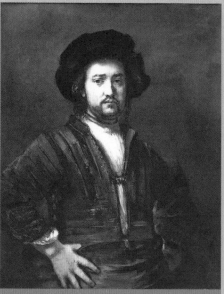

2009
Portrait of a Man, Half-Length, With His Arms Akimbo
Rembrandt van Rijn
Oil on canvas, 1658
42 x 34 inches (107 x 87 cm)

£20.2m/$33.2m

2016

Portrait of Maerten Soolmans
Rembrandt van Rijn
Oil on canvas, 1634
82 x 53 inches (208 x 132 cm)

Portrait of Oopjen Coppit
Rembrandt van Rijn
Oil on canvas, 1634
82 x 53 inches (208 x 132 cm)

€160m/$170m FOR THE PAIR

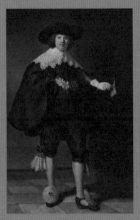 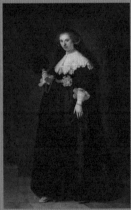

The Soolmans/Coppit portraits broke the record for the sale of Old Masters at auction, previously held by Peter Paul Rubens, whose *Massacre of the Innocents* had fetched £49.5 million in 2002. Who made the record-breaking bid? The portraits were jointly acquired from the owner, Éric de Rothschild, by the Louvre in Paris and the Rijksmuseum in Amsterdam – under an agreement in which the portraits will be shown alternately in each museum, but always kept together.

The paintings had been owned by the Rothschild family since 1878 and had not been exhibited in public since 1956. Art historians expressed concern that constant travel to and from the two museums would be bad for the paintings' conservation prospects.

GOING FOR A SONG?

Is there such a thing as a bargain Rembrandt? In 2015, one was found in the New Jersey auction house of Nye & Company.

DESCRIPTION IN CATALOGUE:

"19th-century Continental School painting, Triple Portrait with Lady Fainting" Revealed after sale as: *Smell*, a panel from Rembrandt's series on the 'Five Senses'. Painted while he was still a teenager, working in Pieter Lastman's studio.

Valued at ...

$800

It was spotted by a number of bidders, and eventually sold for ...

$870,000

USA

The Metropolitan Museum of Art, New York
Including:
Portrait of Herman Doomer, 1640
Aristotle with a Bust of Homer, 1653
Flora, c. 1654

Frick Collection
Including:
The Polish Rider, c. 1655
(a questionable attribution with a great story attached)

National Gallery of Art, Washington
Including:
Saskia van Uylenburgh, the Wife of the Artist, completed c. 1638–40
The Mill, c. 1645–8
Lucretia, 1664

UNITED KINGDOM

National Gallery, London
Including:
Portrait of Aechje Claesdr, c. 1634
Saskia van Uylenburgh in Arcadian Costume, 1635
Belshazzar's Feast, c. 1636–8

The Wallace Collection, London
Including:
Jean Pellicorne with his son Caspar, c. 1632
Susanna van Collen, wife of Jean Pellicorne with her daughter Anna c. 1632

National Gallery of Scotland, Edinburgh
Including:
A Woman in Bed, c. 1647

IRELAND

The National Gallery of Ireland, Dublin
Including:
Landscape with the Rest on the Flight into Egypt, 1647

FINDING REMBRANDT

Famous though the self-portraits are, there are plenty of other stars in the Rembrandt firmament. Biblical and mythological subjects are often painted using recognizable models, and his other portraits offer a vibrant glimpse into Amsterdam society of the mid-17th century. From Europe to America, here are some galleries that offer a good cross-section, including two very famous paintings that turned out not to be Rembrandts after all.

FRANCE

Museé du Louvre, Paris
Including:
The Supper at Emmaus, 1648
Bathsheba at Her Bath, 1654
Slaughtered Ox, 1655
St Matthew and the Angel, c. 1661

THE NETHERLANDS

Rijksmuseum, Amsterdam
Including:
The Night Watch, 1642
The Sampling Officials of the Amsterdam Drapers' Guild, 1662
Portrait of a couple as Isaac and Rebecca, known as *"The Jewish Bride"*, c. 1665

The Mauritshuis, The Hague
Including:
The Anatomy Lesson of Dr Nicolaes Tulp, 1632

SWITZERLAND

Kunstmuseum Basel, Basel
Including:
David Presenting the Head of Goliath to King Saul, 1627

ITALY

Uffizi Gallery, Florence
Including:
Portrait of an Old Man, c. 1665

SPAIN

Museo del Prado, Madrid
Including:
Judith at the Banquet of Holofernes, 1634

RUSSIA

The Hermitage Museum, St Petersburg
Including:
Descent from the Cross, 1634
Flora, 1634
Danae, 1636
Portrait of an Old Man in Red, c. 1652–4

GERMANY

Gemäldegalerie, Berlin
Including:
Minerva in her Study, c. 1631
Double portait of the Mennonite preacher Cornelis Claesz Anslo and his wife Aeltje Gerritsdr Schouten, 1641
Tobit and Anna with the Kid, 1645
Susanna and the Elders, 1647
Joseph Accused by Potiphar's Wife, 1655

The gallery also includes the much-discussed *The Man in the Golden Helmet*, c. 1650, which is now assigned to Rembrandt's circle, rather than the man himself.

Staatliche Kunstsammlungen, Dresden
Including:
The Abduction of Ganymede, 1635

Alte Pinakothek, Munich
Including:
The Descent from the Cross, c. 1632–3
The Raising of the Cross, c. 1633
The Holy Family, c. 1634
The Ascension of Christ, 1636
The Resurrection of Christ, 1639

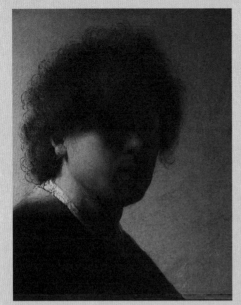

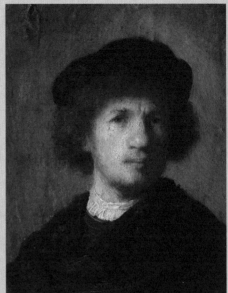

1620s

Self-portrait
Rembrandt van Rijn
Oil on panel, c. 1628
9 x 7 inches (23 x 19 cm)
Rijksmuseum, Amsterdam

1630s

Self-portrait
Rembrandt van Rijn
Oil on copper, 1630
6 x 5 inches (16 x 12 cm)
Nationalmuseum, Stockholm

RECOGNIZING REMBRANDT

Rembrandt was not a traveller; once based in Amsterdam, he mostly stayed there. Today, though, the portraits of the man have travelled far further than the artist ever did, and we recognize him instantly. While it's hard to compute exactly how many self-portraits there are, due to the fluctuation of many Rembrandt attributions, there are probably around 50 paintings, made across five decades. Here are five that take the viewer from the painter's youth to his old age, all in public collections.

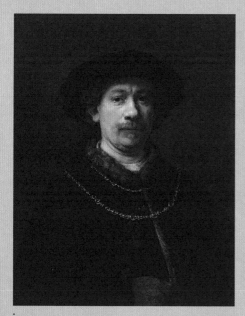

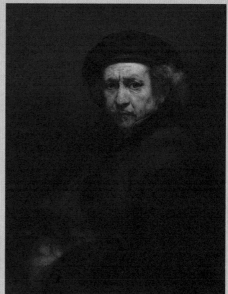

1640s

***Self-Portrait with Beret
and Two Gold Chains***
Rembrandt van Rijn
Oil on panel, c. 1642
28 x 22 inches (72 x 55 cm)
Thyssen-Bornemisza Museum,
Madrid

1650s

Self-portrait
Rembrandt van Rijn
Oil on canvas, 1659
33 x 26 inches (85 x 66 cm)
National Gallery of Art, Washington

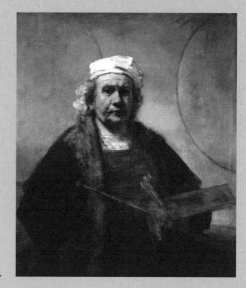

1660s

Self-Portrait with Two Circles
Rembrandt van Rijn
Oil on canvas, c. 1665
45 x 37 inches (114 x 94 cm)
Kenwood House, London

CHARACTERIZING REMBRANDT

The vicissitudes of Rembrandt's life have made it catnip to directors, with mixed results. Few could fail to enjoy Alexander Korda's tour de force, starring Charles Laughton, while some of the others on the list are worth seeking out as curiosities. And the final item – not a film, but a graphic novel – is perhaps the liveliest evocation of all. Typex's bawdy, lively drawings bring a feeling of the true spirit of Rembrandt to his comi-tragic biography.

01 DIE TRAGÖDIE EINES GROSSEN (THE TRAGEDY OF HOLLAND'S GREAT MASTER)
1920, Arthur Günsburg

A true curiosity – a silent costume drama made in Germany and portraying Rembrandt as a revolutionary among his peers. Rarely seen, but well worth the effort. Rush to view if it appears at an art house or film festival near you.

02 REMBRANDT
1936, Alexander Korda

Taking up the story shortly after Saskia's death, Charles Laughton makes Rembrandt his own with a characteristic – at times melodramatic – performance. His real-life wife, Elsa Lanchester, plays a bashful Hendrickje.

03 REMBRANDT FECIT, 1669
1977, Jos Stelling

An experimental Dutch treatment of Rembrandt's life, breaking away from a narrative structure and looking at what it might have been like to be Rembrandt. Both admired and criticized when it was released, today it seems almost as much of a period piece as Korda's version.

04 NIGHTWATCHING
2007, Peter Greenaway

Enthusiasts for *The Draughtsman's Contract* will be unsurprised that Greenaway turns the story of the painting of *The Night Watch* into a dramatic whodunnit. Martin Freeman plays the lead role in an energetic and theatrical story, which led to ...

05 REMBRANDT'S J'ACCUSE
2008, Peter Greenaway

So good, they made it twice. This is the documentary version of Greenaway's earlier film, which conducts an in-depth analysis of *The Night Watch*. For true Greenaway enthusiasts only.

06 REMBRANDT EN IK (REMBRANDT AND I)
2011, created by Marleen Gorris

A four-part Dutch mini-series studying Rembrandt from the viewpoints of those close to him – episodes focusing on Jan Lievens, Saskia, Govaert Flinck and Rembrandt's daughter, Cornelia, look at four different periods in the painter's life.

07 REMBRANDT BY TYPEX
2013, Raymond Koot

Not a movie, but something just as good, if not better. Koot, aka Typex, is a well-known Dutch cartoonist, and this graphic novel, commissioned to mark the reopening of the Rijksmuseum after a 10-year facelift, and offering an episodic record of Rembrandt's life, is a worthy celebration. Vivid and energetic, every frame teems with atmosphere.

TYPEX
REMBRANDT

LEGACY

The Anatomy Lesson of Dr Nicolaes Tulp

trade

bourgeoisie

Bathsheba

The Jewish Bride

Old Master

Rembrandt

Leiden Hendrickje

patron

militia

teacher

Frans Banninck Cocq observer

inventory

Geertje Dircx

Amsterdam

Rubens

extravagance

guilders

baroque

gamboge

stereo blindness

humanity

Saskia

plague

commission

The Night Watch

etching

self-portrait

chiaroscuro

Dutch Republic

revolutionary

earth pigments

studio

pupils

print

palette

Guild of St Luke

The Hundred Guilder Print

Amsterdam Town Hall

bankrupt

collector

Latin School

oils

provenance

heiress

genius

Rozengracht

Jan Lievens

Gerrit Dou

miller's son

overspending

wealth

success

rented grave

history painting

Oude Kerk

The Low Countries

group portrait

shadows

STEALING REMBRANDT

Rembrandt comes in ninth on the list of the 10 most stolen artists published by the Art Loss Register in 2012, having clocked up a total of 337 thefts. Even so, he comes a long way behind Picasso, Dali or even Andy Warhol. Of course, this may be because there are fewer Rembrandts to steal.

TOP 5 THEFTS ...

PLACE

WORCESTER ART MUSEUM, BOSTON

YEAR

1972

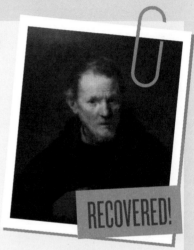

RECOVERED!

ARTWORK / DETAILS

Saint Bartholomew

Stolen along with two Gauguins and a Picasso. It was the world's first armed robbery at a museum.

Recovered from the hayloft of a Rhode Island pig farm one month later.

PLACE

TAFT MUSEUM OF ART, CINCINNATI

YEAR

1973

RECOVERED!

ARTWORK / DETAILS

Portrait of an Elderly Woman
Man Leaning on a Sill

Ransom money paid: $100,000

Ransom money recovered $99,976

The thieves had spent the missing $24 on fast food.

Recovered after a week. The thieves stole the least-valuable Rembrandts on the premises, thinking that because they were large, they must be worth more. A recent assessment found that the works were most likely to be by students or followers of Rembrandt, rather than the man himself, adding insult to injury.

PLACE

ISABELLA STEWART GARDNER MUSEUM, BOSTON

YEAR

1990

ARTWORK / DETAILS

Christ in the Storm on the Sea of Galilee

Stolen with other artworks including a Vermeer, a Manet, several drawings by Degas and a tiny etched self-portrait no bigger than a large postage stamp, also by Rembrandt. The art was never recovered and the stolen pictures' empty frames still hang sepulchrally on the museum gallery's walls.

Total estimated value of 13 pieces:

$500 MILLION +

PLACE

NATIONALMUSEUM, STOCKHOLM

YEAR

2000

ARTWORK / DETAILS

Self-Portrait

Stolen along with two Renoirs. The artworks were removed – James Bond-style – at gunpoint, in a speedboat. They were subsequently recovered in Copenhagen, September 2005.

PLACE

DULWICH PICTURE GALLERY, LONDON

YEARS

1966, 1973, 1981 & 1983

ARTWORK / DETAILS

Portrait of Jacob de Gheyn III

Nicknamed 'The Takeaway Rembrandt', the winner's prize for the most-stolen Rembrandt must go to a picture that has been taken – and recovered – four times.

Estimated current value:

$13 MILLION +

STOLEN 4 TIMES!

RECIPE FOR A REMBRANDT

He's been dead since 1669, so how could a fresh work by Rembrandt have been unveiled in April 2016? A recent technical experiment, 'The Next Rembrandt', involving personnel from Microsoft, the Delft University of Technology, the Mauritshuis and the Rembrandt House Museum, used algorithms to analyze his work. A 'recipe' was then created for a brand-new Rembrandt: a three-dimensional painted picture made entirely by software.

A PORTRAIT

CAUCASIAN MALE

AGED BETWEEN 30 AND 40

WHITE COLLAR

FACIAL HAIR

WEARING DARK CLOTHING

FACING RIGHT

WEARING A HAT

It took

18

months to create a brand-new 'Rembrandt'.

It consists of more than

148

million pixels.

It is based on

168,263

fragments of original Rembrandts.

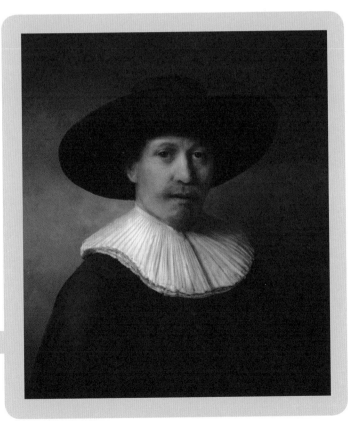

BIOGRAPHIES

Saskia van Uylenburgh (1612–42)

The couple married in 1634, and lived lavishly together – Saskia frequently posing as the painter's model – for the next eight years, until she died, aged just 29. She gave birth to four children, but only Titus survived.

Constantijn Huygens (1596–1687)

A true Renaissance man who combined the roles of diplomat, scholar, poet and scientist with that of being secretary to Prince Frederik Henrik in the Hague, Huygens was Rembrandt's first important patron.

Jan Lievens (1607–74)

Fellow-apprentice of Rembrandt in the studio of Pieter Lastman. The two shared a studio afterwards, before Rembrandt left for Amsterdam and Lievens for England. Works by Lievens were still in Rembrandt's collection on his bankruptcy.

Titus van Rijn (1641–68)

Rembrandt's only surviving child with Saskia. After Rembrandt was declared bankrupt, Titus formed a business with Hendrickje to look after his father's interests. In 1668 he married Magdalena van Loo but died just a few months later.

Pieter Lastman (1583–1633)

Born in Amsterdam, Lastman studied in Italy for three years, where he was impressed by the work of Caravaggio, an admiration which he may have passed on to his pupils, Rembrandt among them.

Jan Six (1618–1700)

Son of a wealthy family and long-time friend and patron of Rembrandt, Six was to become mayor of Amsterdam in old age. He was the son-in-law of Dr Nicolaes Tulp, whose anatomy lesson was famously painted by Rembrandt.

Cornelia van Rijn (1654–84)

Rembrandt's daughter with Hendrickje. After Rembrandt was declared bankrupt, the painter Christiaen Dusart, a friend of Rembrandt, was appointed her guardian. In 1670 she married Cornelis Suythof and the couple emigrated to Batavia in Indonesia.

Geertje Dircx (c. 1605/10–c. 1656)

Hired to care for Titus and run the house, Dircx quickly became Rembrandt's mistress. Supplanted by Hendrickje Stoffels, she sued the painter for breach of promise; he had her committed to a *spinhuis*, or house of correction, in Gouda, where she stayed for five years.

Hendrickje Stoffels (1626–63)

Joined Rembrandt's household around 1646. She became his mistress, displacing Geertje Dircx, and remained with him until her death. She regularly posed for him, and is believed to be the woman depicted in *Bathsheba*.

Frans Banninck Cocq (1605–55)

Heir to a rich father, and man-about-town in Amsterdam, Banninck Cocq is the fashionably attired central figure in Rembrandt's masterpiece *The Night Watch*.

Gerrit Dou (1613–75)

Famous for being Rembrandt's very first pupil, taken on at the age of 14, and staying for about three years. He was commercially successful in later life, specializing in small and minutely detailed genre scenes, very different in style from those of his master.

Hendrick van Uylenburgh (c. 1587–1661)

Emigrating to Poland as a boy, Van Uylenburgh trained as a painter and bought art for the King of Poland before returning to the Dutch Republic in 1625. He became a successful dealer, running a busy studio where Rembrandt spent time as chief painter.

- ● family
- ● artist
- ● patron
- ● dealer

INDEX

REMBRANDT'S PALETTE

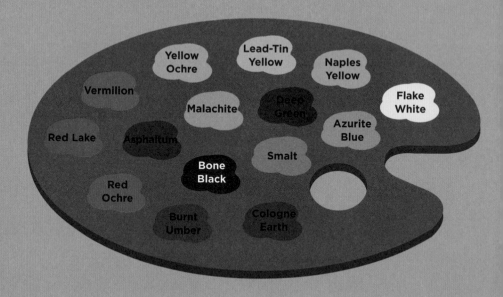

Rembrandt habitually used 15 or more colours, and also mixed colours to rich effect.